CW00552761

PULL MY DAISY

Narration by Jack Kerouac

for the film by Robert Frank
and Alfred Leslie

Introduction by Jerry Tallmer

STEIDL

Pull My Daisy was shot on 16 mm. black-and-white film in the loft studio of the painter Alfred Leslie on Fourth Ave. in Manhattan, New York City. Shooting began in January, 1959 and the film was completed in April, 1959. Running time is 28 minutes.

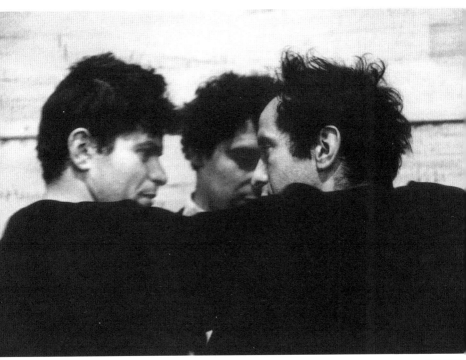

CAST

The Bishop Mooney Peebles

Allen Ginsberg Himself

Gregory Corso Himself

Peter Orlovsky Himself

Girl in Bed Denise Parker

Milo Larry Rivers

The Bishop's Mother Alice Neal

The Bishop's Sister Sally Gross

Carolyn Beltiane

Little Boy Pablo Frank

Pat Mezz McGillicuddy David Amram

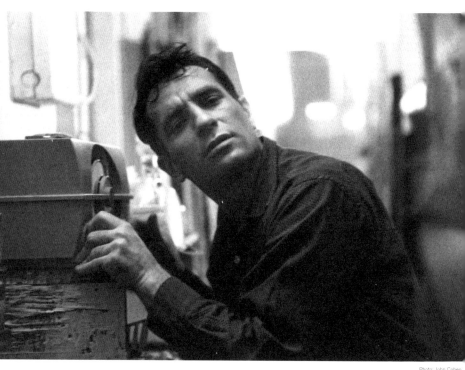

PULL MY DAISY

TIP MY CUP

ALL MY DOORS ARE OPEN

CUT MY THOUGHTS FOR COCONUTS

ALL MY EGGS ARE BROKEN

HOP MY HEART SONG

HARP MY HEIGHT

SERAPHS HOLD ME STEADY

HIP MY ANGEL

HYPE MY LIGHT

LAY IT ON THE NEEDY

Pull My Daisy
Lyrics by Jack Kerouac and Allen Ginsberg
Music by David Amram
Singer: Anita Ellis

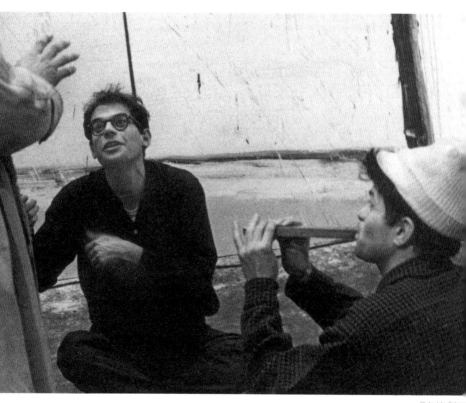

Pull my daisy

tip my cup

all my doors are open

Cut my thoughts

for coconuts

all my eggs are broken

Jack my Arden

gate my shades

woe my road is spoken

Silk my garden

rose my days

now my prayers awaken

Bone my shadow
dove my dream
start my halo bleeding
Milk my mind &
make me cream
drink me when you're ready
Hop my heart on
harp my height
seraphs hold me steady
Hip my angel
hype my light
lay it on the needy

Heal the raindrop

sow the eye

bust my dust again

Woe the worm

work the wise

dig my spade the same

Stop the hoax

what's the hex

where's the wake

how's the hicks

take my golden beam

Rob my locker

lick my rocks

leap my cock in school

Rack my lacks

lark my looks

jump right up my hole

Whore my door

beat my boor

eat my snake of fool

Craze my hair

bare my poor

asshole shorn of wool

say my oops

ope my shell

Bite my naked nut

Roll my bones

ring my bell

call my worm to sup

Pope my parts

pop my pot

raise my daisy up

Poke my pap

pit my plum

let my gap be shut

Allen Ginsberg & Jack Kerouac

My admiration for *Pull My Daisy* is unimpeachable, for I have a terrible secret to reveal now: the Beat Generation seemed to me ex post facto before it began, and with very rare exception its prose and poetry has floated past me as muzzily as a ferris wheel when you're drunk. This was in a way strange – the double-muzzy effect – since, being a Greenwich Villager and a newspaperman, I have had a not unfriendly acquaintanceship with many of its major domos, including most of those on either side of the camera (no plural) of *Pull My Daisy*.

I suspect that's one reason I like the movie: it shows me people I know doing the things they do. It shows me David Amram, for instance, whom I know the best of any here, exactly as David always is, all optimism and courtesy and unfaked sweetness in his great gray floppy sweater three sizes too big in every direction, seeing to it that the ladies get their chairs, toting the chairs over to them with that hunched happy rocking show-boating shyness; here he comes with the chairs and that's Dave Amram and no one else in God's green universe. But this is also what I maybe suspect is the chief flaw of the movie: it is after all so very much "inside" that one wonders how it can possibly be fully appreciated by anyone in said green universe out-side of that handful of people (how many? 2000?) who just happen to have sometime or other met Dave Amram, Gregory Corso, Allen Ginsberg, Jack Kerouac, etc.

Still, there's a girl I've talked with who only recently arrived here from California. She hadn't ever met many or any of the above. And she liked *Pull My Daisy* fine. "I tell you what I liked best," she said. "The way the camera looks the way you look. For example there's one instant, just an instant, when one of the women, the visitors, pulls

down her skirt. The camera flicks on it, at it, and by it just the way your eye would. Watch for it."

When I went back to refresh my memory recently, damned if I didn't miss that instant. Which shows you how natural it must have been. However I didn't miss noting how naturally and casually the camera observed the six ways that at least six different people lit and smoked their cigarettes; or how it just managed to ascertain that it was a Penguin Puzzle book with which someone had propped the pedal of the organ; or how it caught the precise amount of day-old coffee in the pot on the stove; or how it so quickly and fluidly established the complete "geography" of the apartment in which most of the picture takes place. Take the john, otherwise known as can, crapper, or bathroom. We see a small rectangular post card or photo or museum reproduction, too far away for details. Next we see that it is tucked into the edge of a mirror. Then we see a lamp in the mirror, and the angle of reflection gives us our bearings in the room. Then we see that the mirror is fastened to the back of a door; and then the door opens and someone comes out; what he's coming out of is the bathroom. Of course. We knew it was there all the time. Or from now on we'll know it. There's something else you notice on second or third viewing: absolutely the entire movie pivots around, and is dominated by, the icebox. One of the best shots of all shows the Bishop in his white suit against the white of the icebox. And the configuration of the box figures in some way in the activities of all others in the film – as surely it would in the real life in that room. Its cinematic emphasis was, however, altogether unconscious and accidental; cameraman Robert Frank and director Alfred Leslie were not aware of it until it was pointed out to them many months after the completion of their work.

That work began on the first day after New Year's in January, 1959. They took as a skeleton shooting script the third act of *The Beat*

Generation, an unproduced play by Jack Kerouac. They had one camera, one spotlight, one professional performer (the beautiful girl who plays the wife). The interior was Leslie's loft at Fourth Avenue and 12th Street; a Brooklyn warehouse near the East River served for the brief exteriors. Shooting took two weeks – "with interruptions." The cost was $15,000 including cast salaries; nobody worked for nothing except Frank and Leslie.

Pretty soon they began to depart from the written script. Too much good stuff wasn't getting in. Thereafter it went like this, as described by Robert Frank: "You're in a room where people are sitting around. You see something and swing the camera." (If you pay close attention when watching the movie you will see that the camera always swings to the right – clockwise – as the eye does in reading.) "Then Alfred did the directing in his editing. Because after two days of rushes we sort of gave up on the story. It is in this way that it is to my mind a pure film rather than an acting film."

Finally there came the matter of Kerouac's sound track. "Jack had seen the picture twice, silent. He thought he was ready to supply something"– an ad-libbed text along only the sketchiest of predetermined lines – "and we tried it at his house. No good. So we brought him down to a sound studio and put the picture on. He was wearing earphones, feeling great, listening to unrelated jazz. We went through it in three sections, reel by reel, at that one sitting."

So here we are at the heart of the matter, Kerouac's sound track (and "narration" of same) for *Pull My Daisy*. It is without any doubt at least a minor if not major masterpiece and the most honest and honestly funny piece of beatthink within my (however limited) experience. It is also an epic poem, a self-appraisal, a stoicism, a plain unvarnished delight. Nothing but hearing him do it could recapture his fantastic acting ability and mimicry; but of course you may hear him do it when-

ever and wherever you next get a chance to catch the film. It is also, like the movie, an ugly poem – ugly for its put-downs, its woman-hatred, its sexual squareness (all beat sex is square), its holier-than-thou infantile anarchies. This too is part of its honesty. And its beauty – and, inversely, its joy. As with the entirety of *Pull My Daisy*. For the motion picture did not begin, as some think, with *Pull My Daisy*. Nor, as others think, did it end there. It merely moved, as with Vigo's *Zero de Conduite* of twenty-eight years ago, toward "pure film," spontaneity, freedom. That in itself is all one may properly ask for.

(1961)

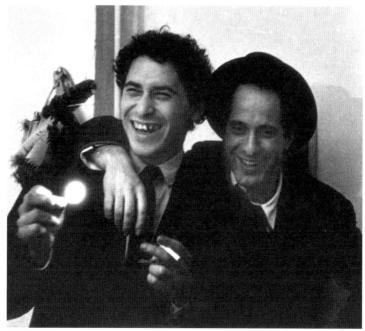

PULL MY DAISY

Early morning in the universe. The wife is getting up, opening up the windows, in this loft that's in the bowery in the lower east side, new york. She's a painter and her husband's a railroad brakeman and he's coming home in a couple hours, about five hours, from the local. 'Course the room's in a mess. There's her husband's coat on a chair – been there for three days – neckties and his tortured socks.

She has to get the kid up to go to school, Pablo. He says, Do I have to eat that stuff all over again, that farina? I ain't gonna say that I'm gonna live a hundred years but I been eating farina for about a hundred years.

(Knock knock)

She says, Button your fly and go out and answer the door.

Gregory Corso and Allen Ginsberg there, laying their beer cans out on the table, bringing up all the wine, wearing hoods and parkas, falling on the couch, all bursting with poetry while she's saying, Now you get your coat, get your little hat and we're going off to school.

Health to you this morning Mr. Hart Crane. No bridge.

He says, Look at all those cars out there. Nothing out there but a million screaming ninety-year-old men being run over by gasoline trucks. So throw the match on it.

Well, that's all right.

And she says, Come on now, got to go to school, learn all about geography and astromomology and pipliology and all them ologies, and poetology, and goodbyeology.

He says, I don't want to go to school.

And they're sitting there talking about Empire State Building and dooms of bridges. And then they wave out—goodbye.

He says, Well, he says, did I tell you about my poem about the Empire State Building that had not doomed the dumb eyes of New York all the time.

Yeah, that's pretty good, he says. I've got a new poem too. Says, Old Ma Rainey dying in an ambulance. Yeah, I've written some poems, I see your poems—

All these poets. Struggling to be poets. Kenneth Fearing and Kenneth Rexroth and W. H. Auden and Louise Bogan, and all the poets. But burning in the purple moonlight at the same time if they wanna.

Well, they turn over their little purple moonlight pages in which their secret naked doodlings do show. Secret scatalogical thought, and that's why everybody wants to see it.

And so here he was and he, and he fell back, he was all excited. And he laid out his paper and his tobacco on the floor. And he made a few little funny signs at me. Gesture all the, die all the, crucified all the, golgotha all the—scenes.

Yes, that's right that's right that's right that's what I said, that's right that's right that's right.

He says, Haven't you read Apollinaire.

What do you mean, I haven't read Apollinaire. I read Apollinaire, I wrote books about Apollinaire, man. Jumping back and down, Apollinaire, man. Come on, don't act like a hep-cat and a hipster. He said, Apollinaire wrote a poem at the grave of Balzac and fell down and Balzac…

Aw, come on, man, he says, I've seen you riding around all day long like that—I'm tired. What are you trying to play violins for? Don't you know that the Empire State Building has fallen underneath the Gowanus Canal?

No, the lower east side has produced all the strange gum-chewing geniuses.

He says, Ah you make me—I could tell you poems that would make you weep with long hair, goodbye, goodbye....

And here comes the man of the house, Milo, followed by Peter the saint. Aw, you bunch of bums, you still hangin around here talkin, drinkin beer, he says. I been working on the railroad all day and I'm mighty tired and I'm going to wash my face, put my lamp away. And meanwhile I gotta tell you the bishop's coming, as you know, and you gotta, you guys have gotta act a little better on behaviour there because you don't want to hang the bish-op up you understand.

Right, Allen, are you all agreed about acting?

Is he a saint?

Yeah, sure, he's a saint, they're all saints, yes.

He says, now fellas, no flutes and no nonsense. I'm going to take my coat off.

Aw, you told me all that this morning, man. Don't bug me no more, I'm tired.

She lays out the table because the salt is drying in the stove.

All right, we're going to have a big night now.

What are you going to say to him?

It's all right, he's a good guy. All right fellows, just sit right there. Just

sit there and write poems or something and I'll go in the bathroom and watch television.

(honk)

It's the bishop, she says.

What, the bishop already, he says, I didn't wash my face yet.

Oh, my daaaa, I'm going back to Venice.

Well, let's go on then and be courtly and polite, as befits poets.

So all the poets meet, the railroad poet: good evening, bishop. I'm awfully glad to see you, sir.

And then the – oh, he's delighted –

And then he meets the other poets – the Russian poet, the Italian poet, the Jewish poet.

The lady, that is, the bishop's mother, is taking off her gloves. And – oh boy, the wife runs around fixing everything and then they help her off with her coat and old Milo says, Won't you sit here. Ah, did you ask the bishop what he wanted?

He said, yes, he wanted a little tea.

Mother, really, you don't have to do that here now. It's not ah – it's not –

Bishop, bishop, I want to ask you some serious questions about Buddhism, which I understand you know all about.

Well, he says, I know something about it.

Nevertheless, he says, is it true that all the ignus that come falling inside the magic beer bottle magian candle stick – he says, I'm awfully sorry, I'm goofing there.

The bishop says, Goofing?

He says, yes, goofing means I'm playing around with words. I want to ask you some really serious questions.

The bishop says, uh huh huh

So Gregory says, Now look, I'm going to ask you something that concerns all of us. He says, Is it true that we're all in heaven now and that we don't know it? And that if we knew it we would still know it. But that because we don't know it we go around and act just the way that we do when we know it. But isn't it strange to realize that Buddhism is all involved with the fact that you don't have to get one way or the other about anything you want really?

He says, Yes, he says, that's well stated. He said, The whole thing depends on ignorance, which is…

And he said, What?

And Allen is saying, Is ignorance rippling up above the silver ladder of Sherifian doves?

He says, Yes yes yes, Sherifian doves, yes. I suppose, he says. In any case, we are not concerned one way or the other about what we're thinking about, about anything in particular. But perhaps we sit in some kind of quiet bliss. And he goes on trying to explain it because he really knows what he's talking about. And he says, Angels and ministers that do stand before me…

And they say, What, angels and ministers?

And here comes old Mezz McGillicuddy, right down the line there. Banging on the organ and he says, Heyo daddy, he says.

And she says, Ooh, if that was not enough! Mezz McGillicuddy, who's disturbed her many a midnight evening.

And ole Milo, he's quite pleased to see him there 'cause he don't – but at the same time he has to talk to the bishop and he says, It's all right, 'sperfectly all right; he's all right, he's my good friend there, he's my good friend.

Old buddy Mezz, going in the toilet to do something.

They sit around the table, they're getting kinda congenial. By God, even the woman feels good and she walks around and old Milo there and sits down and the bishop's feeling pretty good there, he's got some other things to tell 'em, he's got his own thoughts.

And meanwhile Mezz comes out of the toilet. Yes, suh, he says, and he comes out and shakes hands with the bishop's sister. He says, How are you? And he knows old Allen there and he shakes hands, shapes up hands with the bishop's mother and he comes up and shakes hands with the bishop himself.

It's a kind of strange and interesting evening, says the bishop.

The bishop says, Ah, but I don't know anything.

Well, I thought you knew something that you could say.

And he says, Well there's one thing that I don't know what to say and that is to say what I really mean.

Peter says, Have you ever played baseball and seen girls with tight dresses?

The bishop says, Well, I've seen – yes, I suppose so.

He says, Is baseball holy?

Is baseball holy?

The angel of silence hath flown over all their heads.

Yes, it's early, late or middle Friday evening in the universe. Oh, the sounds of time are pouring through the window and the key. All ideardian windows and bedarvled bedarvled mad bedraggled robes that rolled in the cave of Amontillado and all the sherried heroes lost and caved up, and transylvanian heroes mixing themselves up with glazer vup and the hydrogen bomb of hope.

(Child): Humpty dumpty sat on a wall
 and had a great fall
 And all the king's horses
 and all the king's men
 Couldn't fix Humpty together again.

Poor Gregory, the hero of stove and pipe butter.

Well, it could have been better because if Milo wasn't so silly and invited all these silly friends of his, we could have done some kind of impression for the bishop.

"Unrequited love's a bore."

So, it all stands in the bathtub. The Queen of Sheba takes a bath in this bathtub every day.

Dishes, toothbrushes, cockroaches, cockroaches, coffee cockroaches, stove cockroaches, city cockroaches, spot cockroaches, melted cheese cockroaches, flour cockroaches, Chaplin cockroaches, peanut butter cockroaches—cockroach cockroach—cockroach of the eyes—cockroach, mirror, boom, bang—Jung. Freud, Jung, Reich.

Strange thoughts you young, uh, people have.

Is everything holy, is alligators holy, bishop? Is the world holy? Is the basketball holy? Is the organ of man holy?

The bishop says, What, holy, holy? He says, Oh, my mother wants to play the organ.

His mother says, Holy, yes, but I want to play a little music here.

And Pat, being a musician, Pat Mezz Mcgillicuddy gets up and says, Peter, give me the chair so I can let her play on the organ there.

It's a little low, I need a pillow or something.

I'll get you a pillow.

Hearing these people talk about holy, I thought I would pretend to play some little inspirational number. Uh, darling (to her daughter), she says, will you come and pump for me?

She says, Yes mother. I'm coming.

He says, When are we going to blow man, what are we going to do?

He says, Cool it, man, we're going to have a long night tonight. Just cool it and comb your hair.

Man, he says, are we going to stay here all night?

Man, he says, I've got my wife here and my friends here and we'll have to keep cool here a little bit, you know.

Allen's saying, Bishop are holy flowers holy? Is the world holy? Is glasses holy? Is time holy? Is all the white moonlight holy? Empty rooms are holy? You holy? Come on, bishop, tell us. Toy holy? Byzantine holy? Is mock holy? Izzamerican flag holy? Is girl holy? Is your sister holy? What is holy? Holy, holy, holy, holy, holy? And card holy and light holy? Is holy holy? And you holy?

I see that, I think it's best that I go now and go make my holy offices, (laughs) if you know what I mean. And come mother, I think we'd better go home now, it's almost eleven o'clock.

And the wife comes over and she says, Is it, really, almost eleven o'clock — I didn't notice.

Meanwhile these guys aren't paying any attention to all that; they're just blowing. But the other cats are over here talking and, you know, being polite. Some of them are saying something and some of them are saying goodbye. Doing something and saying goodbye and saying goodbye and doing something are both the same.

Do you really have to leave now?

Then the bishop says, We really do.

Look, she says, don't leave.

And he says, Yes, come sister, get your coat.

And she says, I really don't want you to leave. I think we're all having a –

And he says, Yes, he says, but I think we better leave there.

Hey there, he turns around, Milo says then, little boy, you gonna sit on my lap 'cause you can't sleep? What are you doing up so late – I know what you want to do.

He says, Yes, I want to play my horn.

Then, all right, men, let's blow.

Up you go, little smoke.

Up you go, little smoke.

Up you go, little smoke.

McGillicuddy sits and plays the mysterious music that draws all the irishmen and down with the backrooms of dublin. Jamambi, jamambi, jamac, jamac. And elder twine old tweezies fighted the prize. Jamambi, jamambi, jamambi, jamac.

And he says, Wow, let's do something we've never done. Yes, we've heard that.

He says, Come on. Hey, let's play cowboys. I'm gonna be a cowboy, let's play cowboys.

No, I'll be a cowboy – I'll do my Russian cowboy.

No, boy, says Milo, I'll come over here and do my cowboy. A fella got off a dusty old roan one time in south-west Pecos country and stepped up on the sidewalk and spur jingles and he said, Lord! 'Cause there was a preacher in there preaching.

Yeah, yeah, says Gregory.

But at his feet was sitting a wino with his legs crossed drinking wine, saying, Preacher, I understand you. And I aimed my gun right at him and I said, Don't you believe in God?

Pow!

What'd you do that for? – Pow!

All this nonsense. You been doing this all the time. For years you been doing this.

They think it's very funny because they don't know anything about Time magazine.

She says, All this time we should have fed them some food, we should have done 'em some good, we shoulda – all that time you give 'em wine and beer and give 'em all these beatniks in the house.

He says, Ah, shut up, I didn't do nothing, you know. I didn't do nothing and it's not bad. These are nice fellas. They're just sitting – now they're getting up and they're leaving. I don't blame them for leaving.

You don't understand.

He says, Come on, Milo – gang – Come on there, Peter, Gregory, Allen, Come on, let's go. Come on down those steps. Let's go. We'll

go somewhere; we'll find something. Maybe we'll play by fires in the bowery.

She's crying.

He says, come on, he says, don't cry. There's nothing to cry about.

She says, What do you know about what to cry about?

Milo, Milo…

He says, I certainly do know what there is to cry about and it ain't nothing that has to do anything with this that's happening right now.

And the rose swings. She'll get over it.

Come on, Milo. Here comes sweet Milo, beautiful Milo.

Hello, gang.

Da da da da da

And they're going dada da da dada da da da. …Let's go. 'sgo, sgo. …

Off they go.

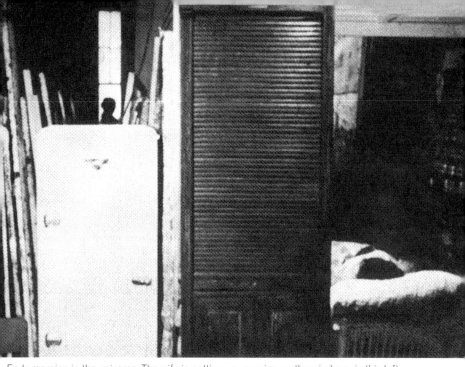

Early morning in the universe. The wife is getting up, opening up the windows, in this loft that's in the bowery in the lower east side, new york.

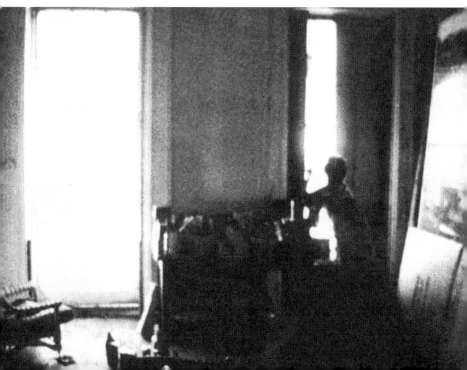

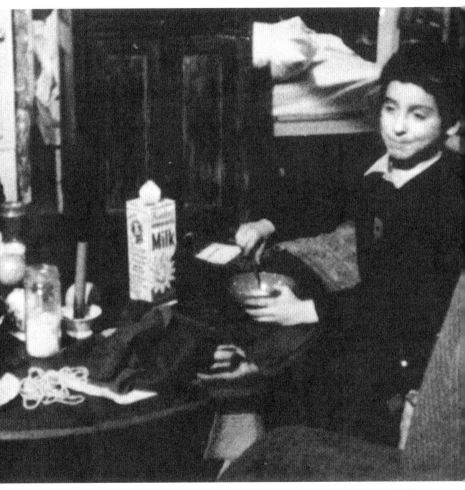

Do I have to eat that stuff all over again, that farina? I ain't gonna say that I'm gonna live a hundred years but I been eating farina for about a hundred years.

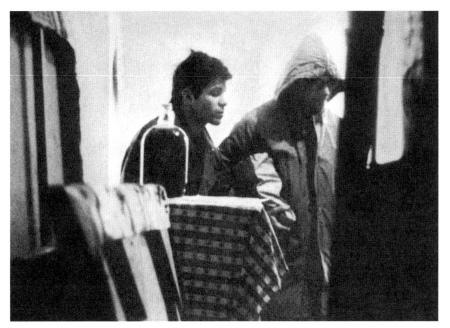

Gregory Corso and Allen Ginsberg there.

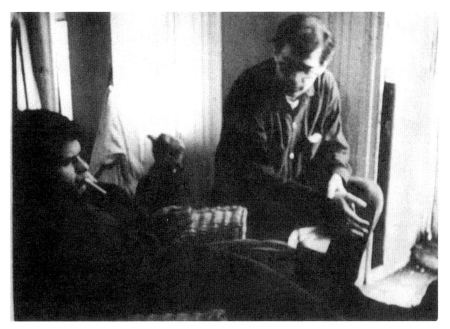

Nothing out there but a million screaming ninety-year-old men being run over by gasoline trucks.

Well, they turn over their little purple moonlight pages in which their secret doodlings do show.

Don't you know that the Empire State Building has fallen underneath the Gowanus Canal?

I could tell you poems that would make you weep with long hair, goodbye, goodbye…

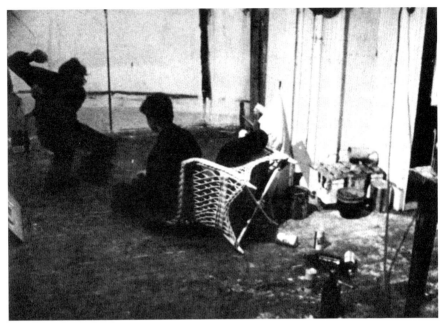

Gesture all the, die all the, crucified all the, golgotha all the – scenes.

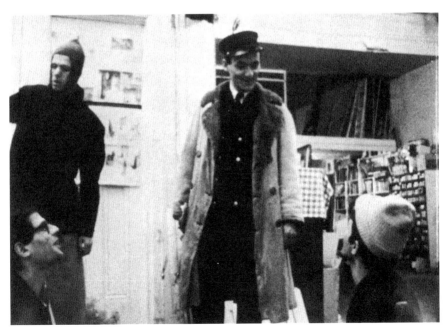

Aw, you bunch of bums, you still hangin around here talkin, drinkin beer...

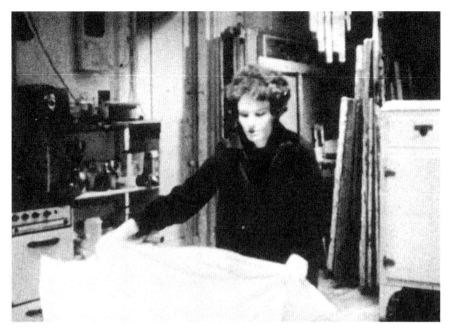

She lays out the table because the salt is drying in the stove.

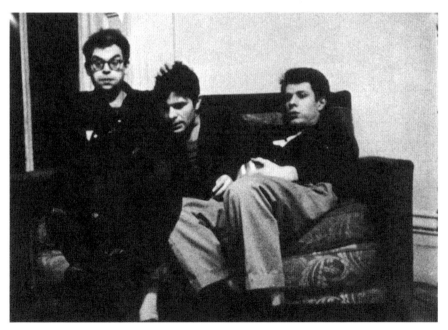

Just sit there and write poems or something and I'll go in the bathroom
and watch television.

Oh, my daaaa, I'm going back to Venice.

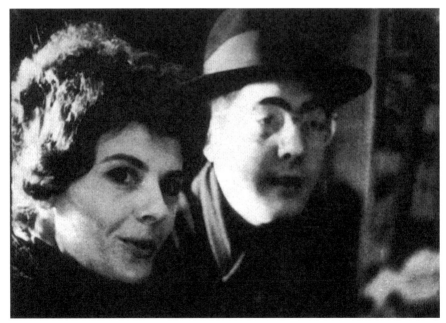

Well, let's go on then and be courtly and polite, as befits poets.

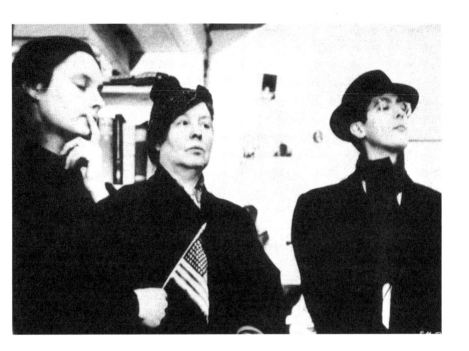

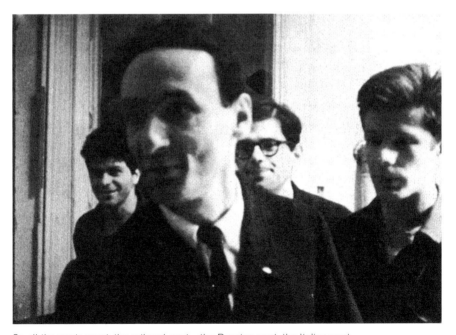

So all the poets meet, the railroad poet...the Russian poet, the Italian poet, the Jewish poet.

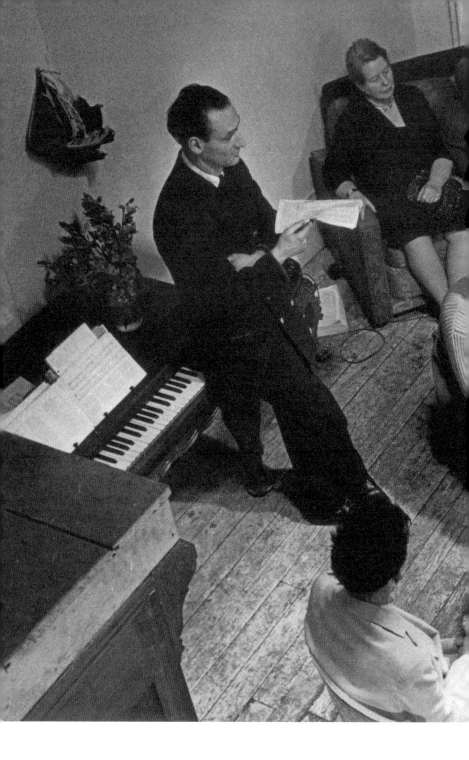

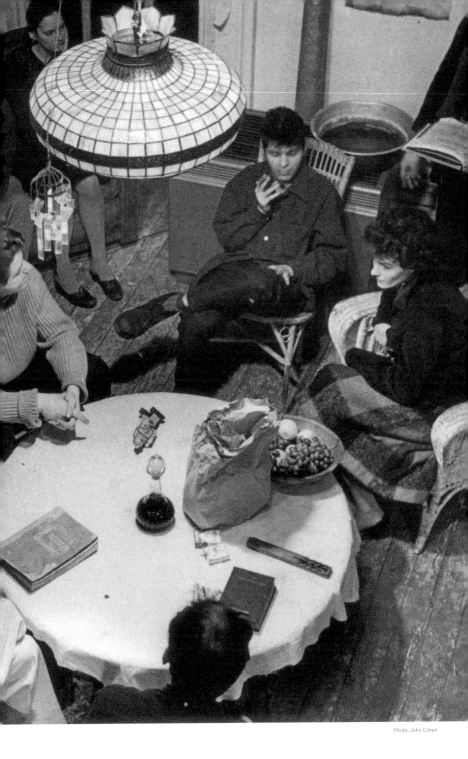

Bishop, bishop, I want to ask you some serious questions about Buddhism.

Is it true that we're all in heaven now and that we don't know it?

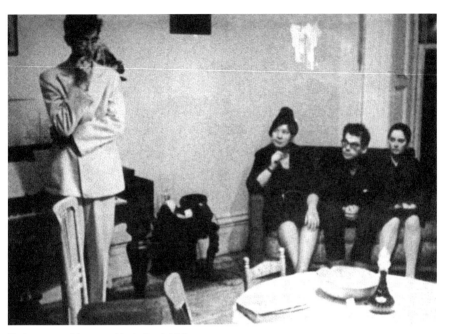

Perhaps we sit in some kind of quiet bliss.

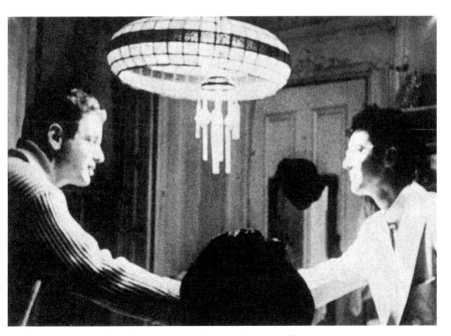

And he comes up and he shakes hands with the bishop himself.

The angel of silence

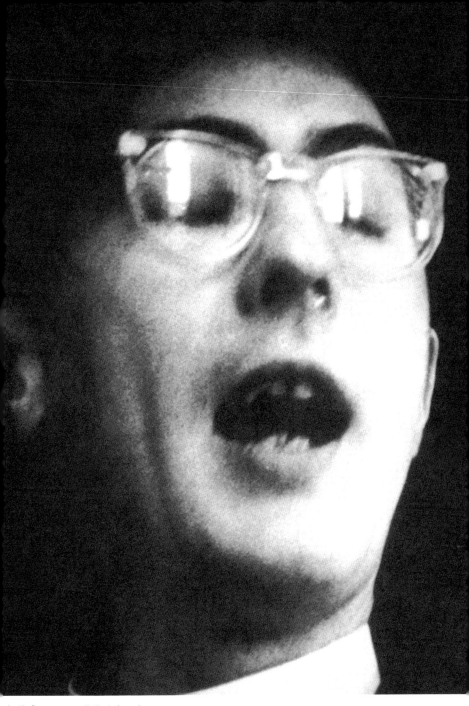

hath flown over all their heads.

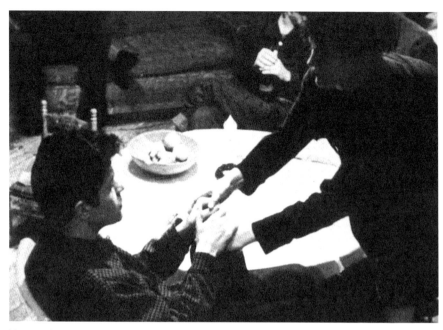

Humpty dumpty sat on a wall and had a great fall.

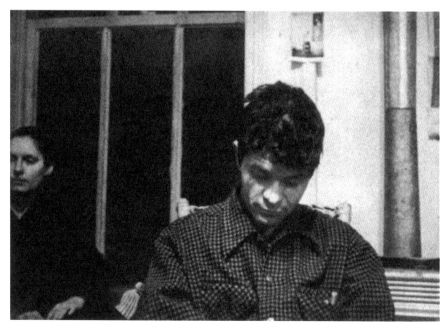

Poor Gregory, the hero of stove and pipe butter.

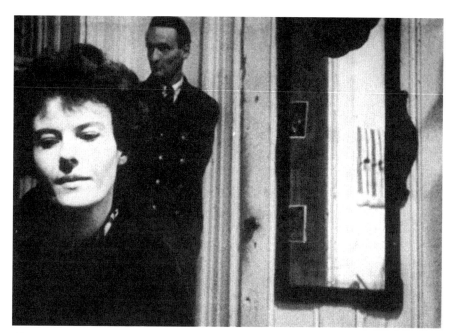

"Unrequited love's a bore."

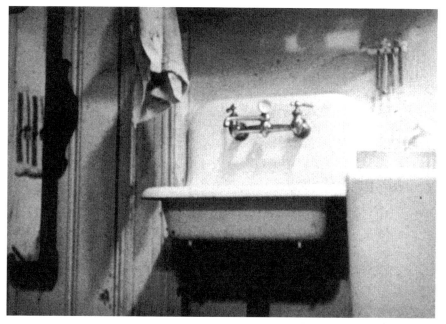

The Queen of Sheba takes a bath in this bathtub every day.

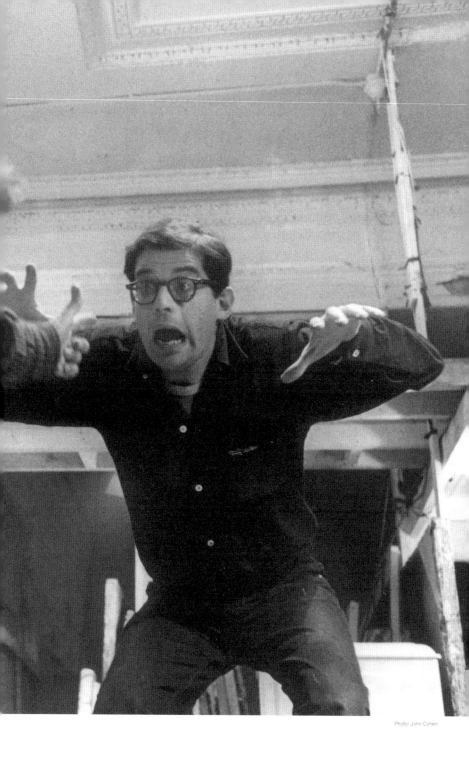

Photo: John Cohen

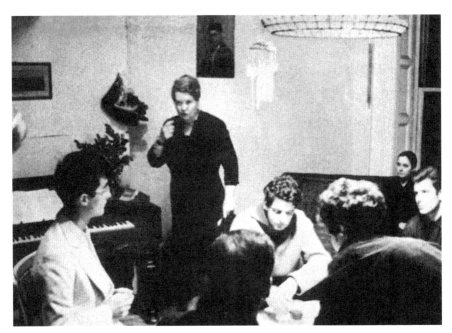

Holy, yes, but I want to play a little music here.

Hearing these people talk about holy, I thought I would pretend to play some little inspirational number.

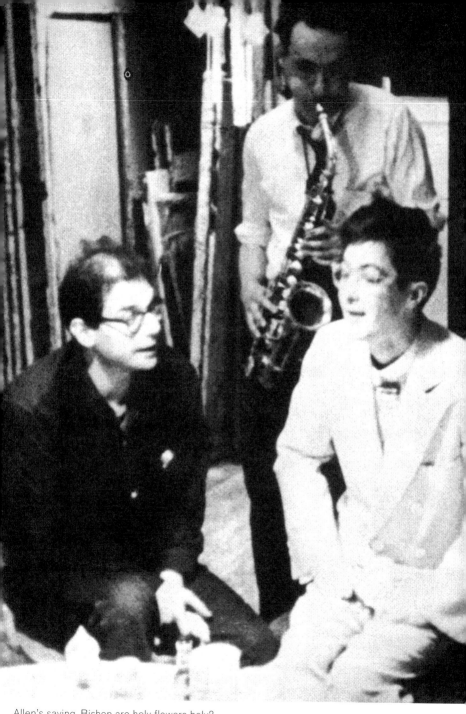

Allen's saying, Bishop are holy flowers holy?

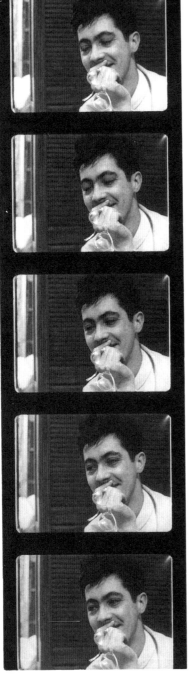

Is the world holy? Is mock holy?

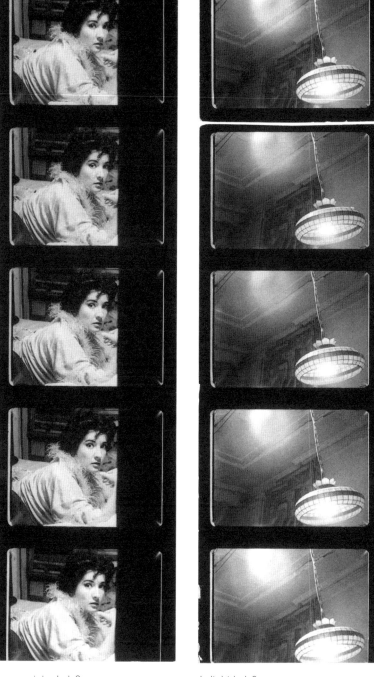

Is your sister holy? Is light holy?

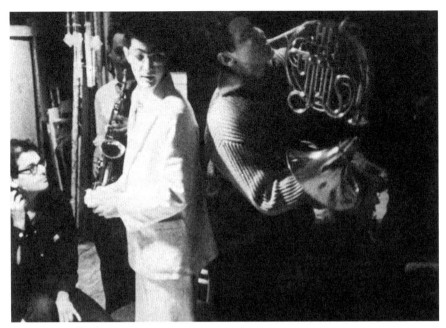

I think it's best that I go now and make my holy offices.

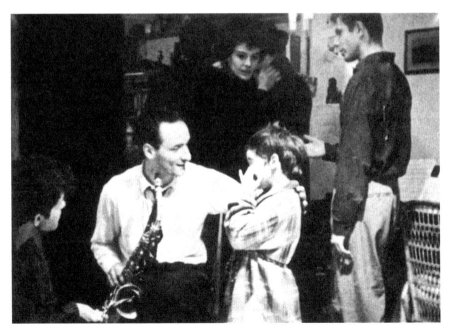

Doing something and saying goodbye and saying goodbye and doing something are both the same.

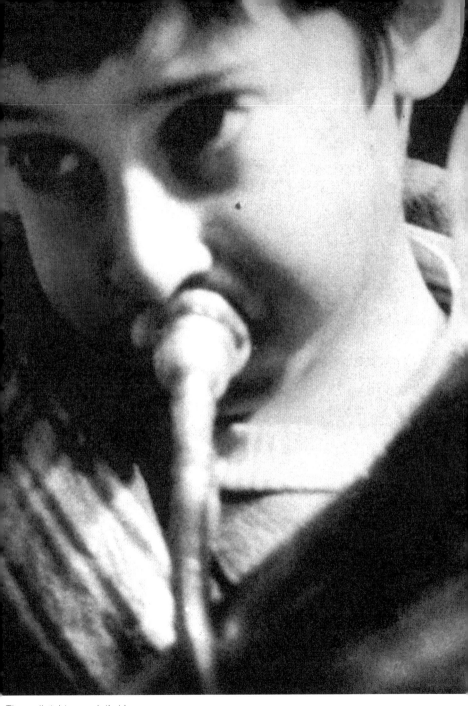

Then, all right, men, let's blow.

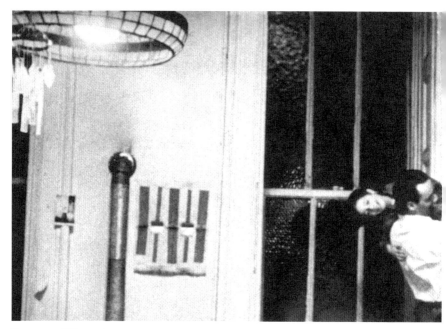

Up you go, little smoke.

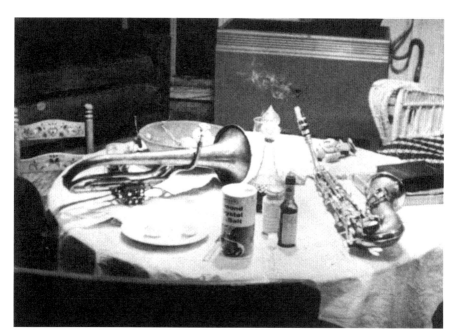

Up you go, little smoke.

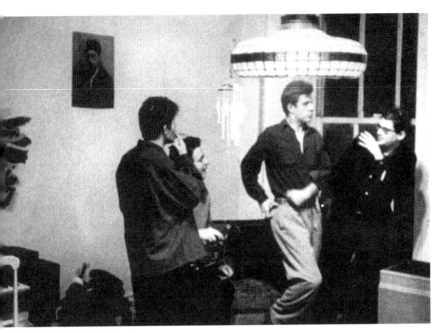

Hey, let's play cowboys....I'll do my Russian cowboy.

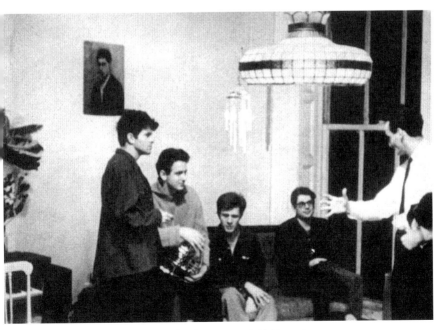

But at his feet was sitting a wino with his legs crossed drinking wine.

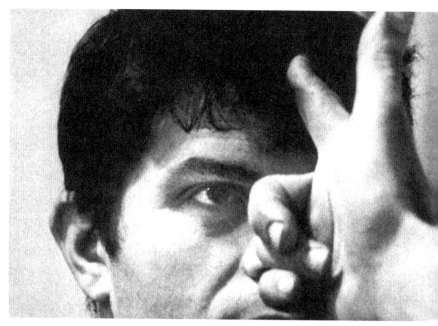

And I aimed my gun right at him and I said, Don't you believe in God?

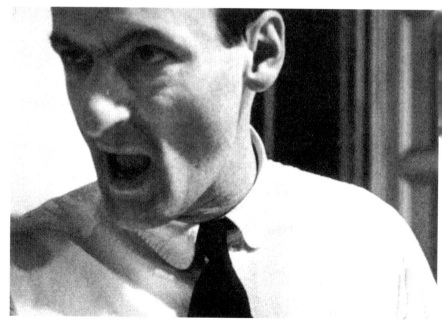

Pow!

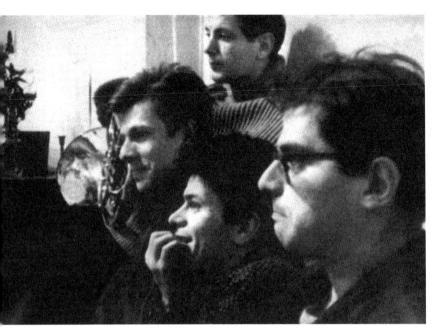

hey think it's very funny because they don't know anything about Time magazine.

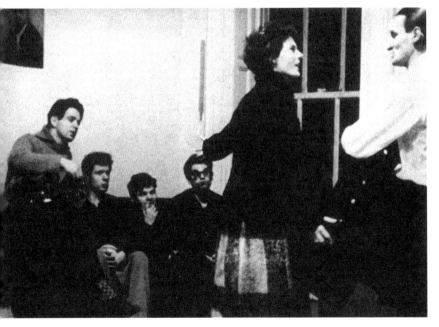

All that time you give 'em wine and beer and give 'em all these beatniks in the house.

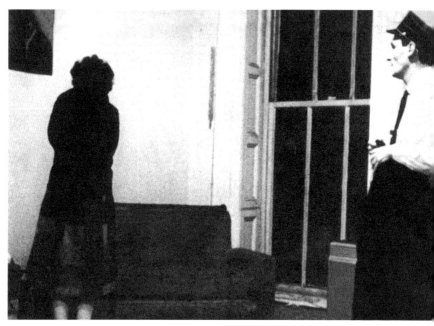

He says, come on, he says, don't cry.

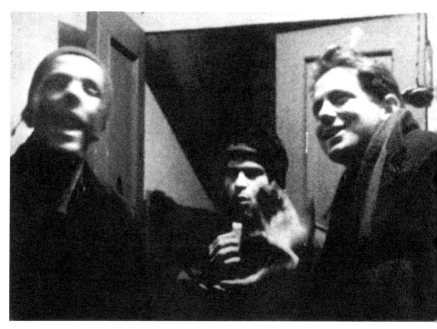

Milo, Milo…

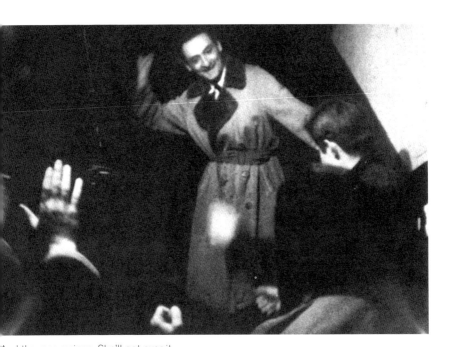

And the rose swings. She'll get over it.
Come on, Milo. Here comes sweet Milo, beautiful Milo.
Hello, gang.
Da da da da da
And they're going dada da da dada da da da....Let's go. 'sgo, 'sgo....
Off they go.

End.

This volume is based on the film
PULL MY DAISY

Directed and produced by Robert Frank
and Alfred Leslie

Story and Idea by Jack Kerouac

Music by David Amram

Sound and film edited by Robert Frank,
Alfred Leslie, and Leon Prochnik

First Grove Press edition 1961
Steidl edition 2008

Design: Robert Frank, Gerhard Steidl and Rukminee Guha Thakurta
Scans: Steidl's digital darkroom
Production and printing: Steidl, Göttingen

Steidl
Düstere Str. 4 / D‒37073 Göttingen
Phone + 49 551- 49 60 60 / Fax + 49 551- 49 60 649
E-mail: mail@steidl.de
www.steidlville.com / www.steidl.de

ISBN 978-3-86521-673-1

Printed in Germany